HELLO COLORING FRIEND!

Thank you for purchasing this book.
I sincerely hope that it will give you
peace and joy as you color these pages.

This is a zone for your creativity and relaxation.

This Book Belongs To:

Colored pencils or pens are best suited
for thispaper. But if prefer to use
markers or paints, please make you
put a few sheets of paper under the
page you are coloring in to avoid
smudges on the bottom pages.

ENJOY WITH COLORING!

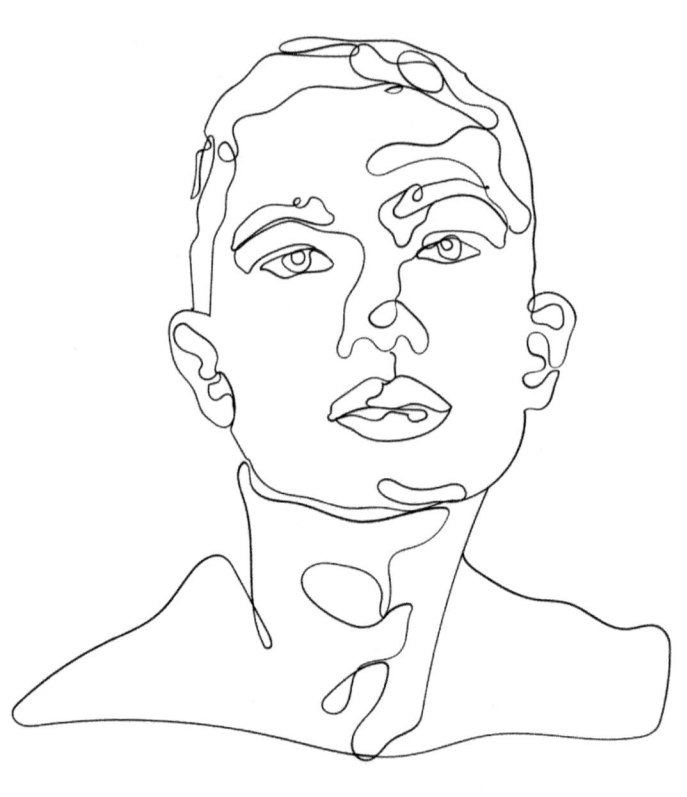

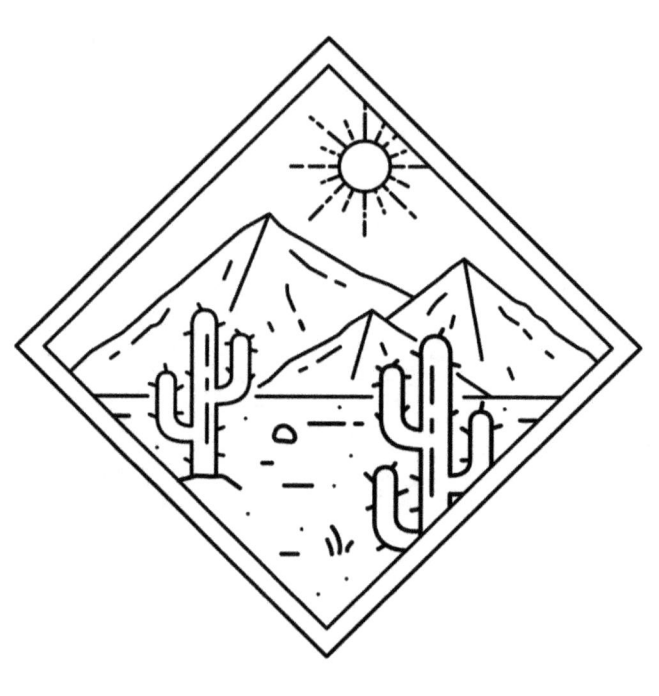

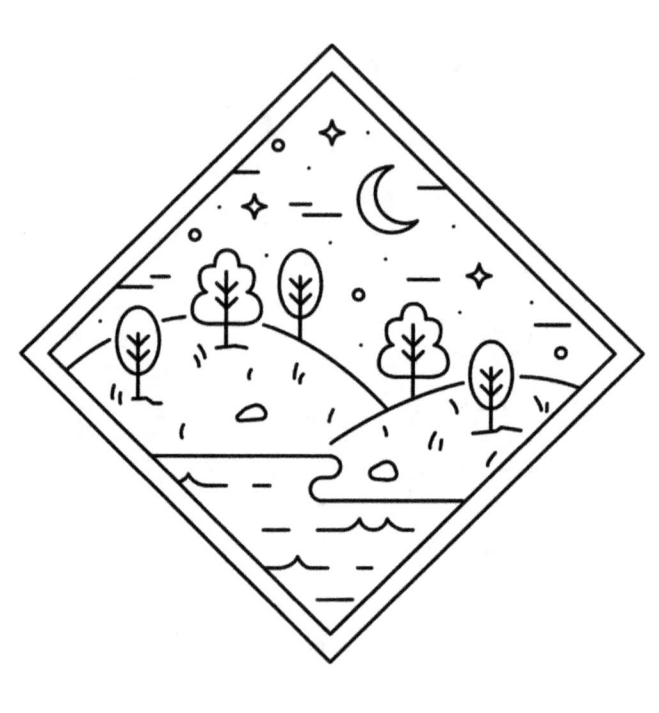

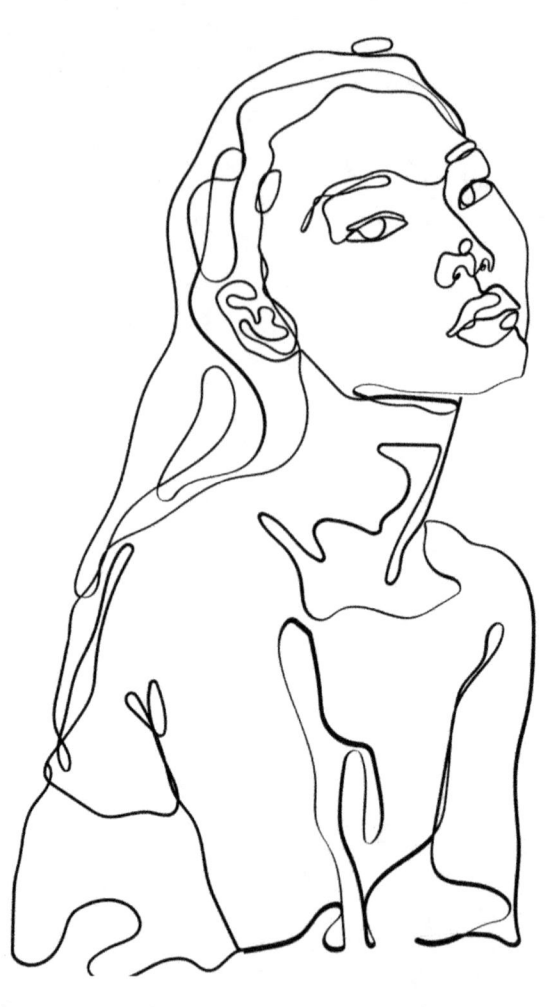

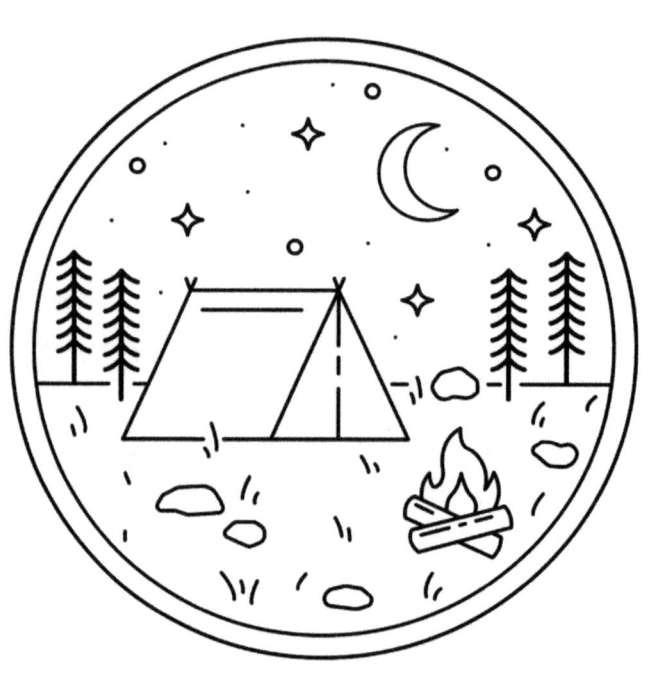

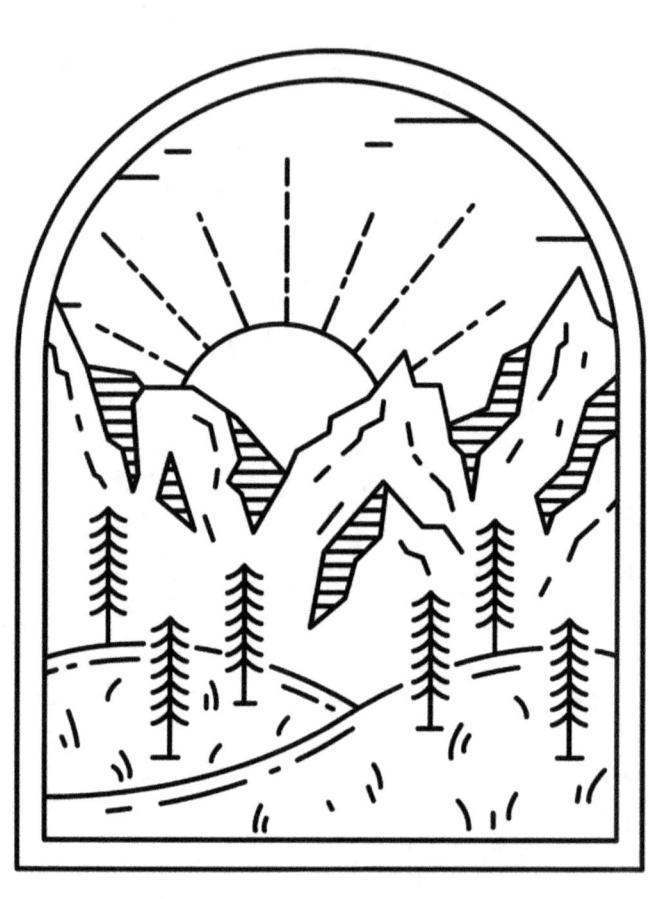

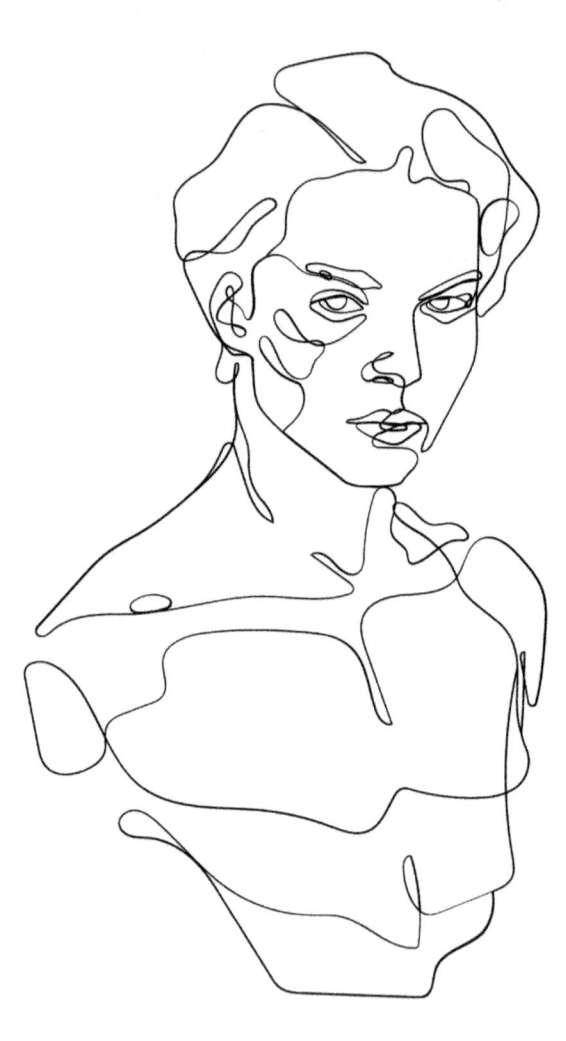

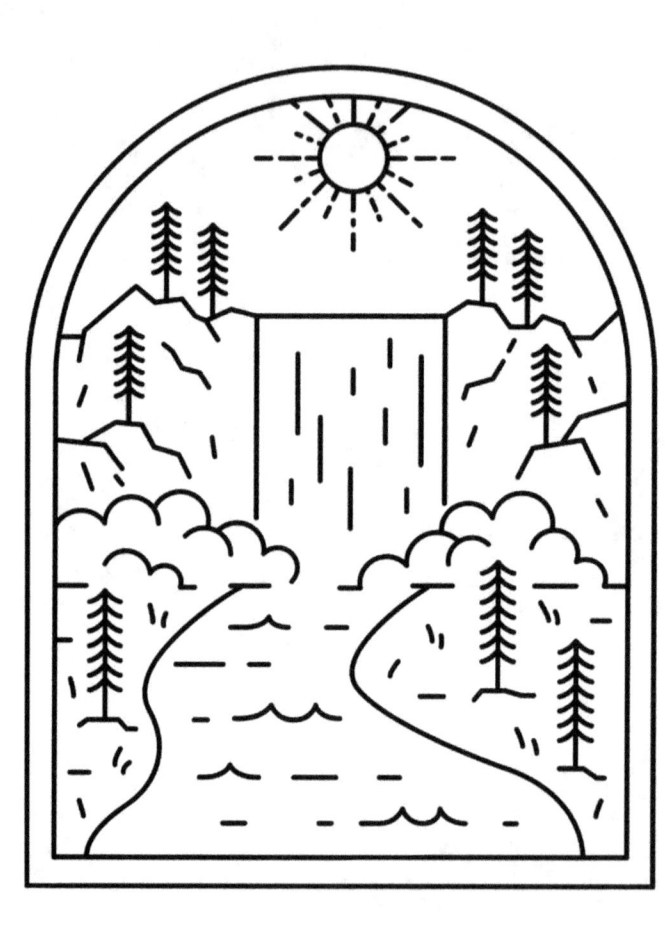

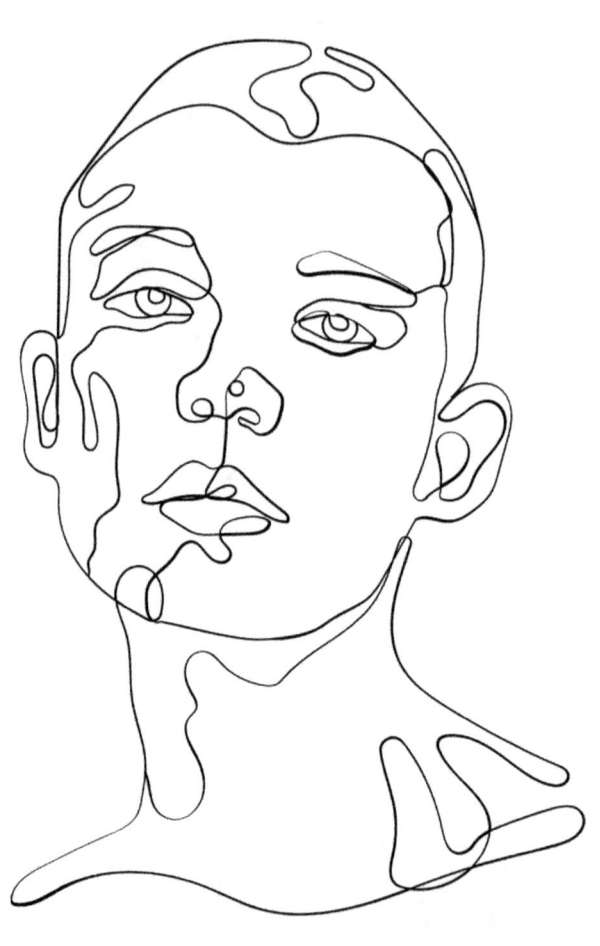

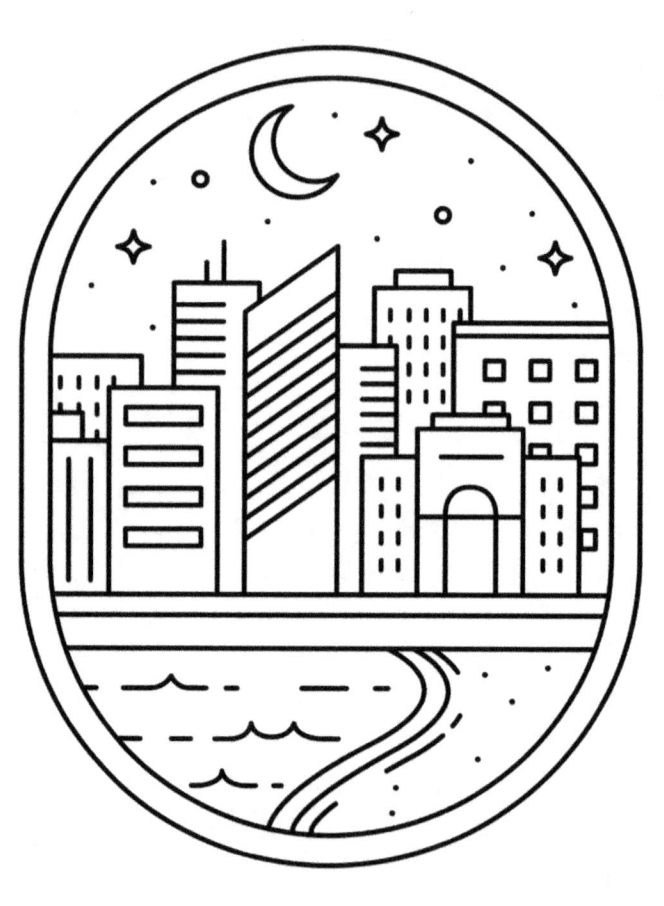

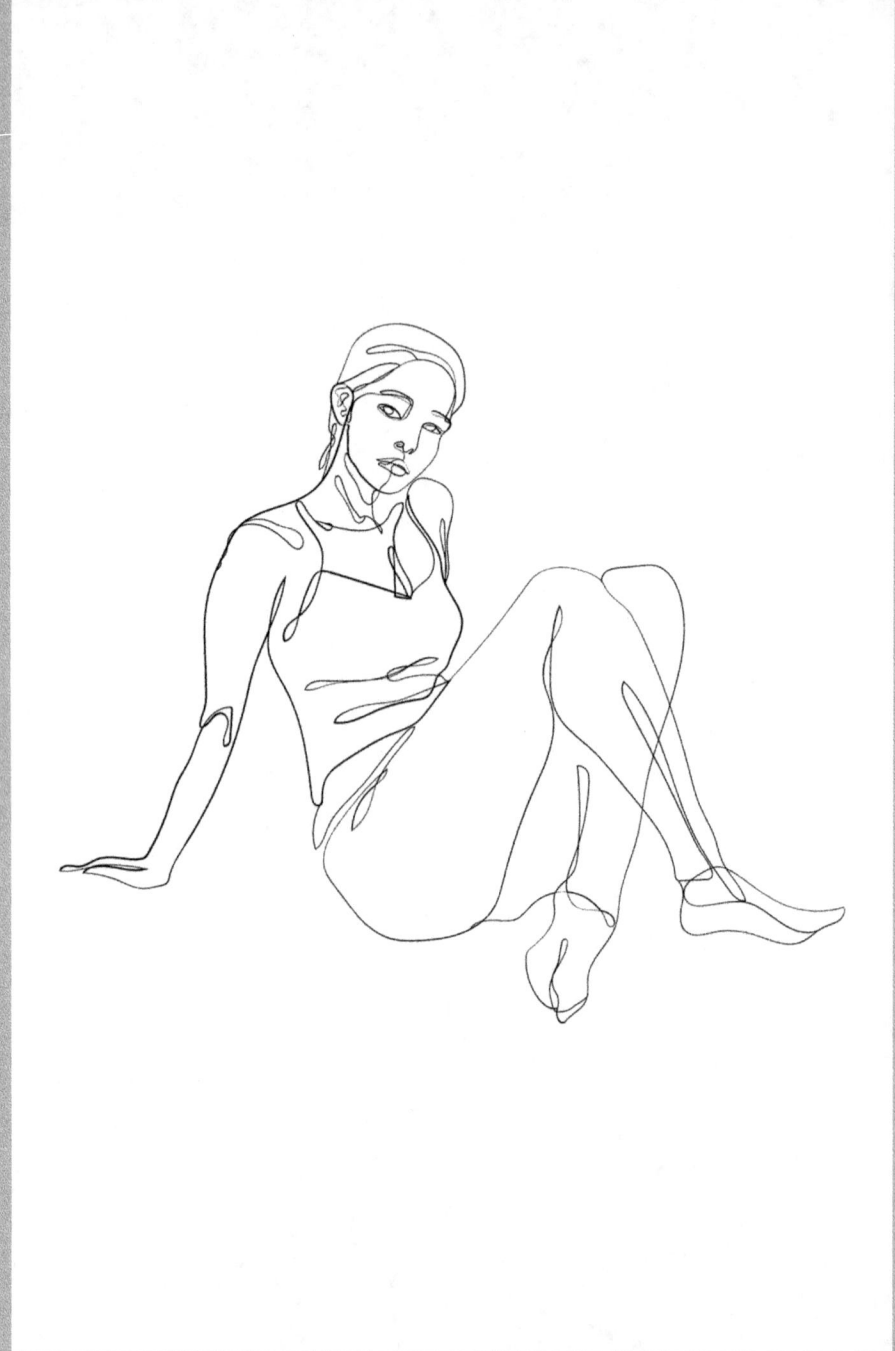

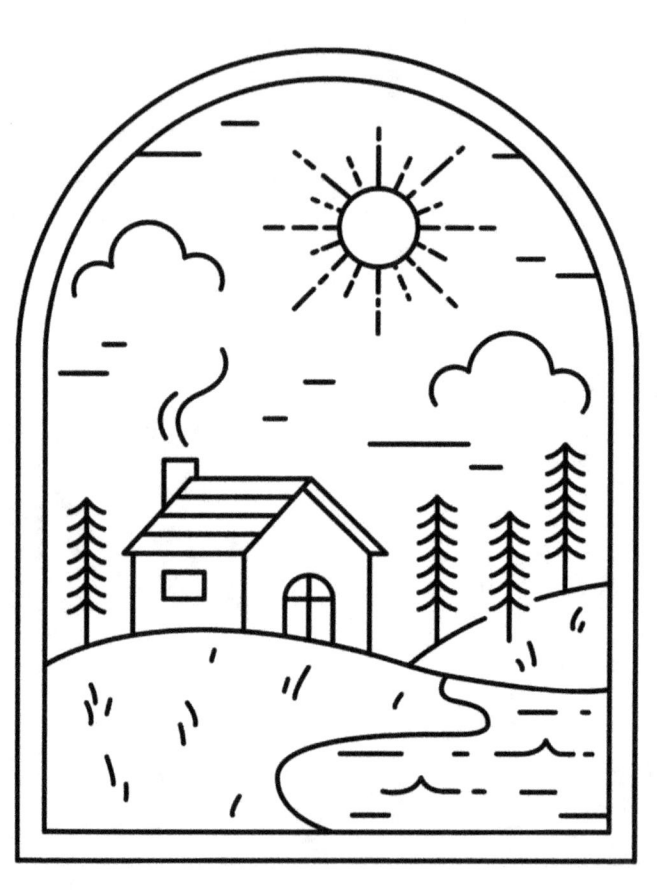

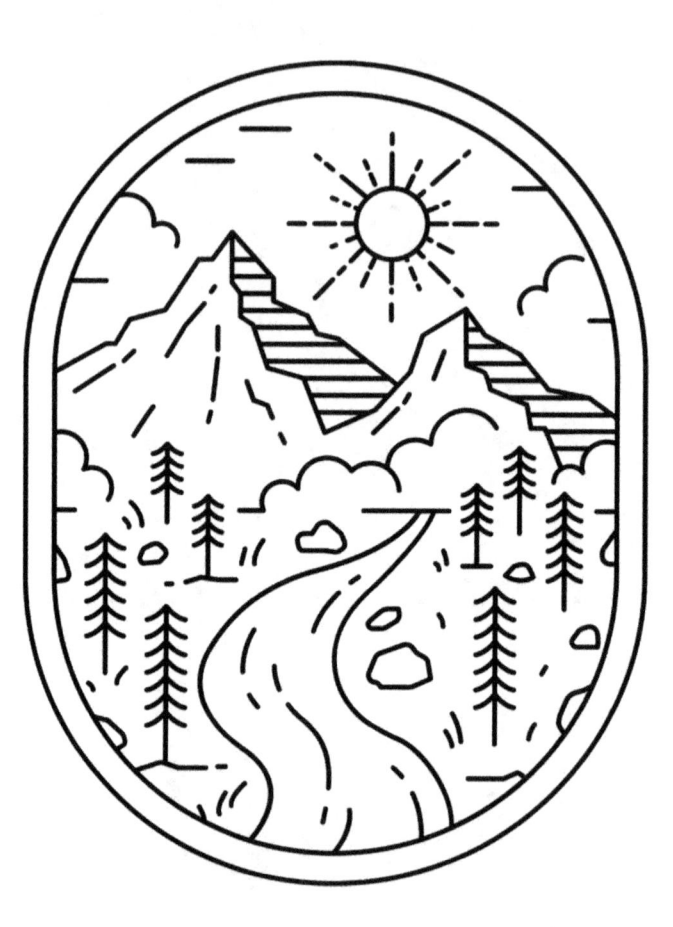

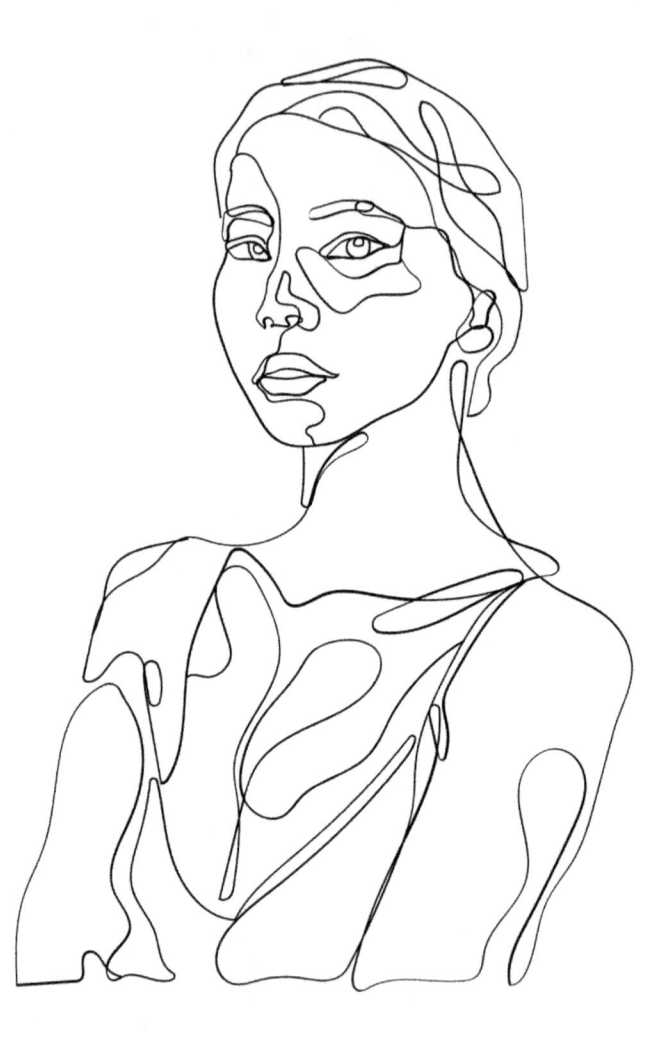

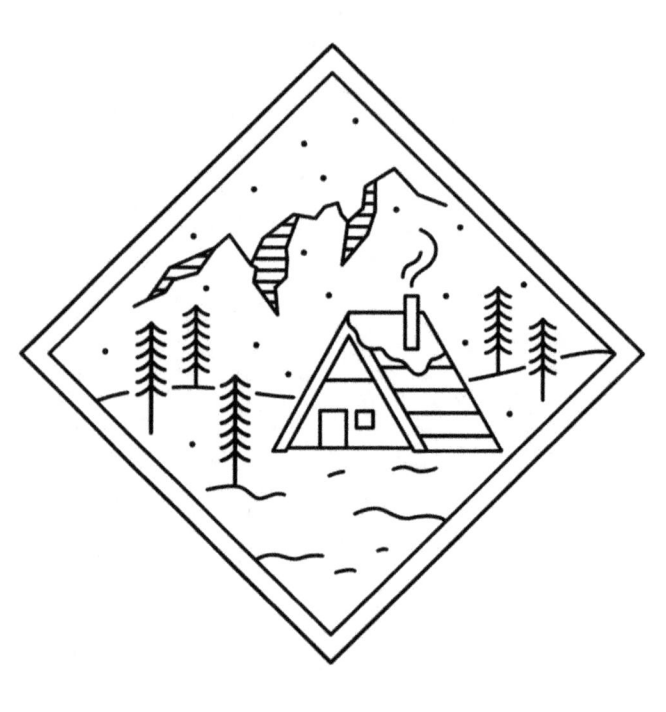

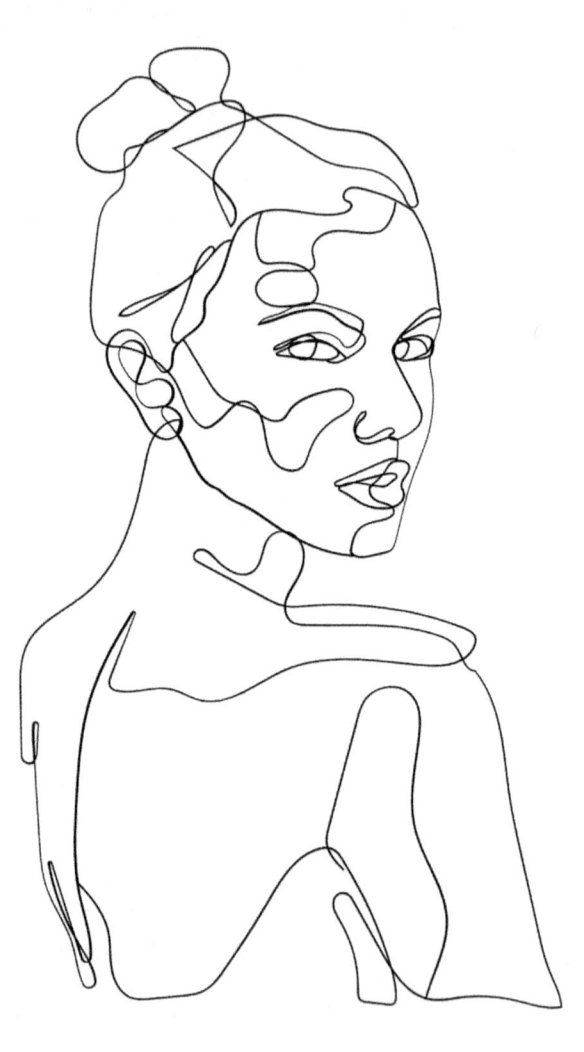

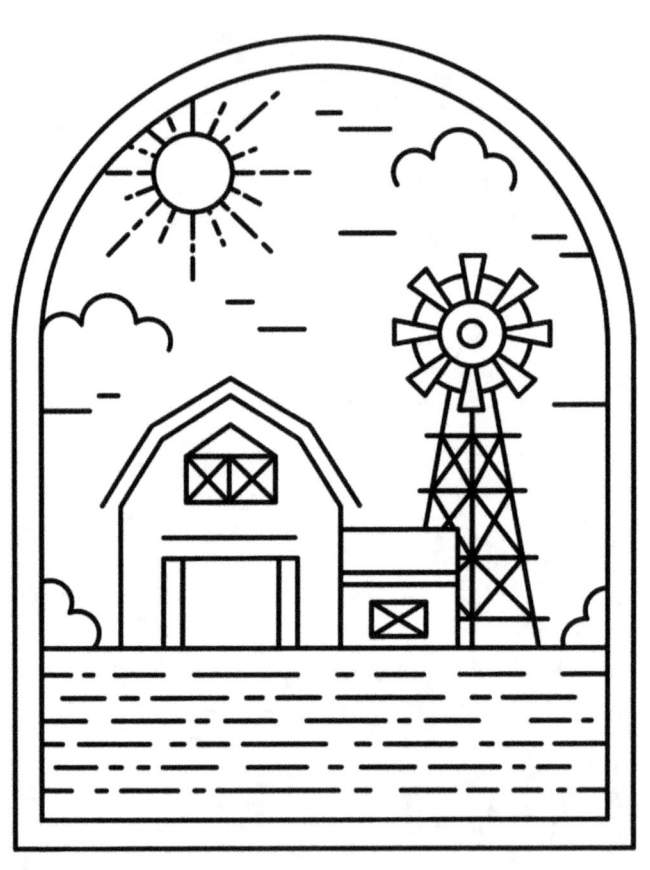

www.ingramcontent.com/pod-product-compliance
Lightning Source LLC
Chambersburg PA
CBHW071947210526
45479CB00003B/845